For Hong Kong in my fiftieth year

Also by Madeleine Marie Slavick

Non-fiction

China Voices with Oxfam
My Favourite Thing with Oxfam
Children in China with Barbara Baker and Michael Karhausen
China – The Dragon Awakes with Lee Ho Yin

Poetry

Something Beautiful Might Happen with Shimao Shinzo
delicate access with Luo Hui
Round – Poems and Photographs of Asia with Barbara Baker

Photography

Ghost Records exhibition with Luo Hui, Toronto
delicate access solo exhibition, in Hong Kong, Singapore, Tokyo
colo(u)r e-book, Toronto
Flesh and Blood exhibition with Susanne Slavick, Sarah Slavick,
 and elin o'Hara Slavick, in Europe, Hong Kong, USA
Together solo exhibition, in Hong Kong, Singapore
Round exhibition with Barbara Baker, in Hong Kong, Cairo
Poetagraphy solo exhibition, Hong Kong

mccmcreations

FIFTY STORIES

FIFTY IMAGES

Madeleine Marie Slavick 思樂維

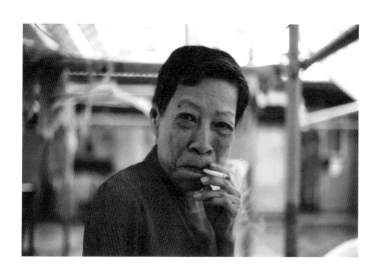

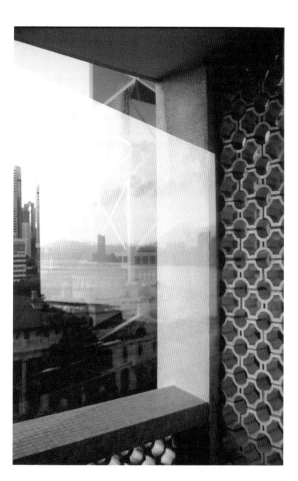

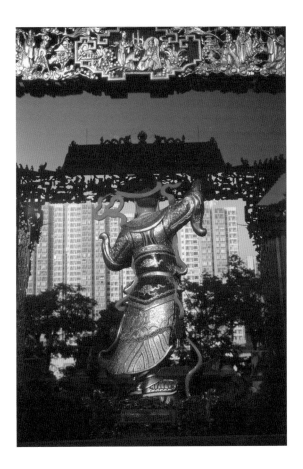

MTR

I stand with my hand in the hand-stirrup, swaying.

When a man leaves his seat at the end of the row, I quickly take it, the metal still warm with his heat. I think of rising again to let him fully leave, but I don't.

I once lived near the terminus of one line and worked near the terminus of another. The commute a sway of another kind.

Someone from another country comes and says the MTR has no smell, and a friend says someday she will sing in the cars.

I have only missed my stop once in twenty-five years, when I was writing a story. I never looked up, never heard the voices telling me where I was, in three languages.

TINY RED LIGHTS

The first night in Hong Kong, I see many tiny red lights.

One red light on either side of the hallway.

One home, one shrine.

I have seen the shrines as the gods of the family, protecting, but later, he says they are gods of justice and that only homes lit with fluorescence have them anymore.

NEIGHBORS

Eight people live in the same amount of space as I do, about five hundred square feet.

They live one floor below me, and we share a roof, one floor above.

Sometimes I want to give them my home and live in a room somewhere in the building, but I stay.

These neighbors make congee, serve it nineteen hours a day, from six o'clock in the morning until one thirty in the morning of the following day.

For five years, I have eaten their congee at the shop two blocks away. I have seen their children sleep in the crib alongside the shop, then use stools as desks for learning how to write, and the other day, they were using mobile phones.

Every day at the shop, a shrine with an electric red light on, next to a television, also on.

Sometimes, the two young children ride on my shoulders up our stairwell, echoing. The two teenagers may help carry heavy bags, as if they are Girl and Boy Scouts, and they are.

When I pass the parents on the stairs, they are going to work, or coming back home, and every time, the mother and I stop in our steps to greet each other.

The first time I met the grandmother, I was hanging out laundry on the roof and she came up to dry garlands of tangerine peel. She shouted a full hello but said the word 'good-bye'.

Every morning in our stairwell, incense from their shrine.

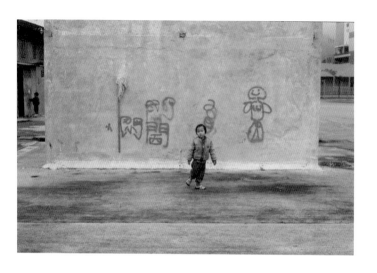

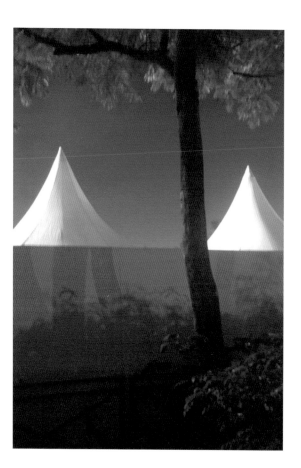

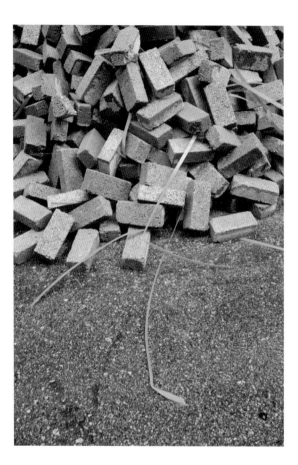

HIGH RISE

A mother and daughter from another city stay in a high-rise hotel near the city center.

Their room on the forty-second floor overlooks a slope and more high rises, upward, downward, as if everything will fall.

They close the curtains but still, they cannot sleep. Their fear is on both sides.

They leave, come to my home, only a few floors above flat land, and still, they tremble a little.

SCENT OF THE MOON

I meet a child whose name comes from a poem in which sleeves are full of fragrance.

One part of the name means full, like the moon, and another part, scent, as in the Hong of Hong Kong. I say I will remember her as the scent of the moon.

I once wrote her a letter enclosed in a packet that used to hold lavender, her other name, in English.

She sent a pink card with purple ink, with two drawn butterflies, two flowers, one tree, and both of us wearing dresses to our knees. She sent a sprig from her garden and asked me to smell.

THREE DAYS

A puppy, weeks old, is stuffed at the bottom of a huge green public garbage can. The squealing high and regular like an insect. We are not sure what the sound is and pull up piles of trash to find it, alive.

My friend washes the puppy with water from her thermos, cradles it in the t-shirt that had been on her back, drives it to a vet, says to her husband that this is how things come into your life, and they prepare to adopt.

Two days later, brain seizures, death.

I tell her she has transformed a death of horror into one of dignity. I tell her she is beautiful. She is.

THREE PHONES

I have never bought a mobile phone.

Maybe it was 2006 when I received the first phone, around the time when shops and restaurants stopped putting a telephone out front for public use.

Curved and silvery, the phone huddled in the hand like a cool shell. It folded, and you could not know the caller until you unhinged it. It had once belonged to a man who said the keys could not be seen clearly, so his daughter found a model to his liking and gave the small version to me.

I kept the little machine inside a wool pouch, until one day, the pouch was lost, and then a few days later, the sound. People could hear my voice, but I never heard anything through the phone again.

The second phone, thick and rectangular, came proportioned like a mahjong tile. It could stand straight on any of its sides. The twelve main buttons in their grid were raised higher, and could be pressed deeper. A friend had stored it inside a shoe box for about a decade, just in case. It lasted one more year.

The third gift greeted me when I once returned to the city, phoneless. Slippery, thin, black, it takes photographs, and can predict the next letter I might type, but I only ask it to give and receive sound and word.

Thank you.

MISSING

One morning, two friends park their bicycles just beyond the outer edge of a very crowded bike zone. When they return from work that night by train, they find their bikes gone.

One government department had removed the bicycles, and within the forty-eight hours that it took my friends to locate their bikes, another department had already sold them at an auction.

I once sold a ring at a garage sale but wanted it back immediately after the man paid the few dollars. He would not return it.

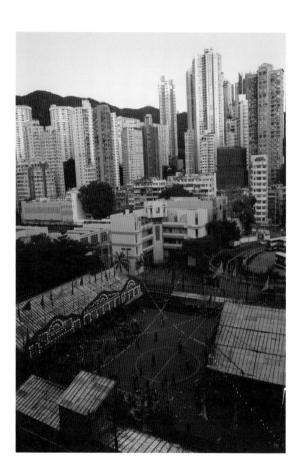

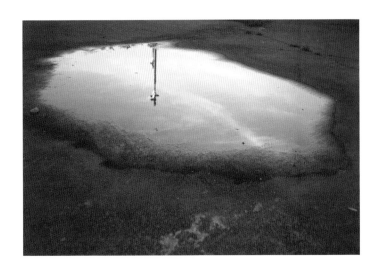

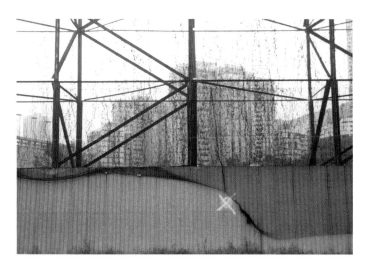

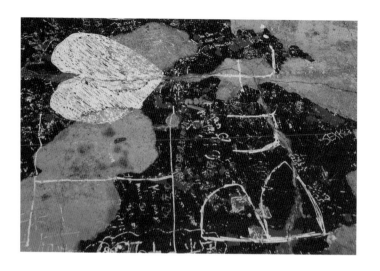

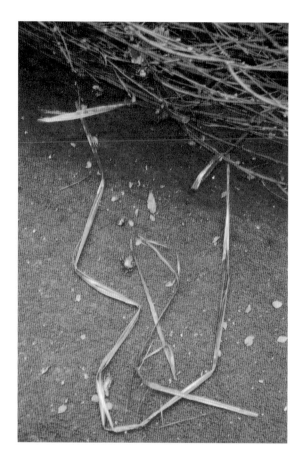

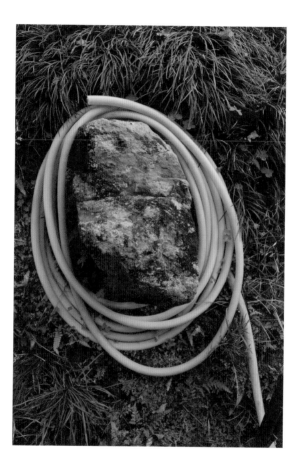

GINGER LILY

The cut blossom and its rush of perfume do not linger. It faints after a day or so.

I have fifty-three of the flowers in my arms. I selected twenty-six and the flower seller gave me the rest for free, with that smile of his, looking downward.

I used to live next to a field of the white flower. Our one-hundred-year-old home had thick stone walls, a clay tile roof, and chickens at the back, along the base of a mountain. The expanse of ginger lily out front.

The house had a tall entrance door, so much taller than I. Smoothen, wooden. In the morning, a long creak in the opening, and in the evening, the hands slid the two wooden bolts shut as if finishing two sentences at once.

The village homes were in one row, our house at the beginning. Neighbors walked past our barking white dog that was given to us for a while, and we would give again.

On the weekends, beer song and the clicking of mahjong tiles. And throughout the day and every night, the elevated hum of the highway one hundred meters away.

We moved there just as the highway opened, and never saw the field of ginger lily without the hum. The four-lane highway led into a two-lane tunnel, a mountain away.

We did our vegetable and fruit shopping in the temporary housing estate on the other side of the hum. Homes here, for maybe ten years, were of sheet metal, corrugated metal, beds sometimes boards. Hawkers worked along the central lane, their fruit in little pyramids, vegetables in mounds. Pork sliced thin, thinner.

One day I was walking home under the elevated highway. An elderly neighbor greeted me, and before I could sense what he was saying and doing, his mouth was on my neck. I did not return the greeting and have never spoken of this.

SEEING

During one month of the year, spirits might come back, and we give them the space they need.

A man looks at my forehead, the whole face. He is the grandson of a person he calls a witch, and says I do not trust.

Only one man has read my palm. We call him a master, and he is. He leads a whole roomful of people to move in grace, he helps a sleepless friend sleep in minutes, and says I do not need.

Yesterday, a lake, crematorium and model airplane site. We see a little white plane crash into a tree. No one dies.

I keep a photograph of a woman who still wanted to live. I called her a tree. She stays in my home, where I also keep the word N-E-A-R.

IN THE PARK

I walk through the park with a poet. We name the trees and wonder how they know themselves.

I walk through with an architect. He says the toilets in the park are among the most expensive in the city.

I walk with cigarette smokers when that was still possible. Now the path is the perimeter.

Every Sunday, the park is full of singing, eating, reading, praying, and for one night of the year, thousands of us believe.

Sometimes, the whirring of bodies and rollerblades, in large loops, or the darting with football or basketball. I have joined several games, with a boy who cheats so sweetly, a whole team of new Christians, and a woman over sixty who dribbles exquisitely.

In a certain season, orange treetops, and in another, the kapok drop cotton pods. Summertime starts with cicadas, a huge bamboo fish might appear in the middle of autumn, and the cooler winter brings trade fairs.

For one week, I stayed in the park every day with my books and furniture, and every night I read aloud to passersby. One day, one poem. One leaf, one moment.

I want to take another afternoon nap on the warm grass.

OLD HOMES

We take a highway, pass an industrial building, turn left up a shaded road above a peach blossom farm, and after the hoardings of a construction site, the road ends.

As we walk to the village, neon-colored pellets dot the grass and paths. Little toy bullets, from boys pretending to be men, or men pretending to be boys, and both pretending to be soldiers.

Once there were rice farmers here, then they became workers in a city somewhere, and now, most of the homes stand abandoned, the household items left intact. Rooms, lives, photographs. Dishes, clothing, calendars.

I have taken two tables, nailless, before they rotted. My sister took bamboo husks to draw on. But we never touch the shrines.

We open a door to the shape of a cat on the living room floor. Thin fur. The bone and flesh gone. Through another doorway, doorless, a tree has grown in the center of the room, and as we enter, a great whoosh.

We never see the bat or bird.

FISH AND CAT

A white fish lay on the eleventh stair, a little body in the rain, and I stay there, listening for the story. I start to walk away but will always return.

Then I meet a cat with long white waves of hair. I approach, let him smell my hand, and he says yes.

MIDDLE OF AUTUMN

Every autumn, our homes are cleansed of all that may not be well.

For three nights, a long body stuck with thousands of lit incense sticks, winds through the neighborhood to the sound of a neon-lit drum. It smokes our streets, smokes our rooms, and when not cleansing, the body of thatch is propped up in an alley. The head elsewhere.

We stay home for the first and third night. The middle night is another autumn event, in another neighborhood, where we send big lanterns, also lit, also handmade, into the night sky.

One lantern we make comes back down, and my friend catches it, like a parent might a child. Another one returns, lands in a tree, but the night is moist, the wind calm, and the leaves do not burn. The rest of our lanterns fly, upward, moonward.

At the end of the third night back in my neighborhood, when the cleansing is complete, the dragon winds into a white truck, turns left from my street, drives to the harbor, and is buried at sea.

NIGHT GIFTS

I find long glow-in-the-dark fingernails and give them to a girl who gets frightened in the night.

When I too was a child, I once dressed as a mummy, strips of white fabric circling my legs and arms, torso and head. We went door to door, fearless, and our candy lasted days or weeks, depending.

Tonight, a few days before Halloween, I am walking home, and two girls wearing long black hats give me two marshmallow candies.

We are all glowing.

ROBBED, BURGLED

I was traveling in another country. A man came near and said he wanted some money. I said I would give him some, but he wanted everything, took out a knife, reached under my winter jacket, and cut the strap of the very slender travel pouch. He ran off with my passport and more.

It took about ten seconds to catch my breath after being so close to a knife. Then I ran in the direction he did, but never found him or anything that had been mine.

I don't remember who brought me to a police station. I think it was a woman. The police clerk wanted to issue the report in his language, not knowing that my city does not use it. In the end, he issued two reports, first writing in his language and then in mine.

I returned home, and for months, I would lose my breath when I saw that knife and heard its swish. I thought that someone just might track me down here, as all of my identification was in that little pouch.

Years later, my camera was gone when I returned home to my flat in a fifth floor walk-up. Also missing was about ten thousand dollars I had just withdrawn from the bank, and a laptop computer with the only files of all of my writing for six years.

It was about seven o'clock in the morning. I had been out singing all night with friends to celebrate a birthday, which meant that the home had been vacant for about twenty-two hours.

I telephoned the police, explained that I had been robbed, and the operator replied, 'No, you've been burgled.'

'OK, burgled,' I said, the first time I had used the word, the first time it had happened.

The police came in about six minutes. The friend whose birthday it was also came, just minutes afterwards. The policemen checked the locks, asked if anyone had a set of keys, said it was not easy to break in. There were four or five policemen looking, thinking, and we noticed a pair of cotton work gloves left behind on a shelf. They took the gloves, but said there would be no fingerprints.

Another set of detectives came about an hour later, asked more questions, and took fingerprints from the desk and filing cabinets, leaving grey oily smudges I never fully removed.

Exactly two weeks later, again I was burgled. I laughed.

Again, the police came in minutes, and again, my friend was at my side. And I cried.

Burglars often return, the police said, knowing people will replace items, and yes, my shiny new desktop computer was gone, along with its shiny white box.

Four months later, I left that burgled flat. Yet I have kept all of the police reports, in three languages, all handwritten.

CARPENTER

A friend has four poles of wood in his home. Hip height. The edges and corners indented, cut through by a carpenter, again and again.

My friend found them near a worksite, and the carpenter did not mind for him to have them.

One night, soon after I moved to a new neighborhood in the city, I found an old wooden bench on a side street. Thinking it discarded, I brought it home, placed it along the foot of my bed, and then a small red television set on top. Late at night, I would sometimes watch this or that on the nine-inch screen.

A few days later, I walked down that street again and saw a carpenter with a new workbench, chained in place. I never did tell him I had taken his bench, but when I left that city flat, I returned it, placing it alongside his new one.

MAMMAL

I killed a mammal today. About a week old.

The little rat was dragging itself across the verandah after I had swept away its bed of twig and leaf from behind a pot. I thought the high-pitched sound might have been a bird.

I looked for other babies, but it limped alone.

When I told my mother this story, she said she had killed a whole family of rats and that she was pregnant at the time.

TWO CRACKED TEETH

I have a reverse bite. A dentist named Pinky tells me so.

I cringe at her name, but see her as perfect otherwise. Communicative. Clear. Sensible. Working at a pace that feels peaceful. She is the first dentist to tell me about the bite and says that together we'll choose the crown.

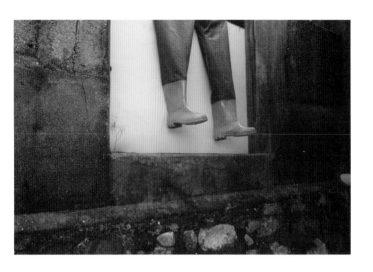

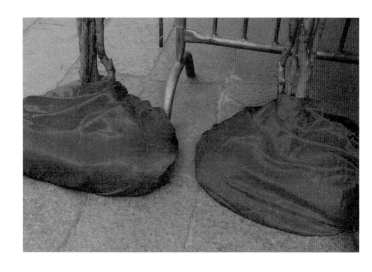

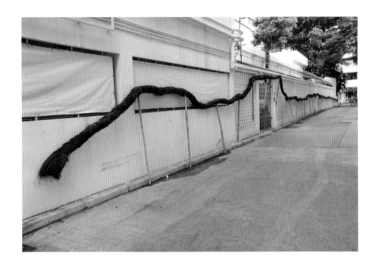

MOVING THE SEA

A few streets away from my home is a brick building, from 1907. It used to be a yacht club, until the sea was moved, in 1938. The stone wall that used to run along the waterfront remains. It is not straight. Like the sea, it waves.

The building once for yachts now belongs to the government. In 2011, they sold the eighty thousand square feet in front of it – space that once was sea – to a company. A hotel will come.

YAHOO

A few years ago, the mmslavick@yahoo account was stolen.
I could never enter it again.

Someone had found a way in, accessed my e-address book,
and wrote to everyone that I needed urgent money.

It was midnight and the written voice was clearly not mine,
but ninety-two friends contacted me anyway, just to be sure
I was not homeless and moneyless somewhere far away.

My father told the hacker that I have much better grammar.
I told everyone that I was safe, happy, loved and loving.

TEMPLE

A massive stone stands in the middle of a temple.

Incense and prayers everywhere, with a red set of stairs on either side of the stone, sixty divinities of time, and a goddess who used to be male.

We enter, center ourselves. One man chants. Many people bow, with three incense sticks for the past, present, future. I do not ask for a fortune to be read.

The temple sits at the junction of two streets. At the point where they meet, a corner window opens, and the goddess becomes visible for all.

Some people bow as they pass by, some hands press together, and many people pause, even from the main road, about fifty meters away.

WRITING IS HOME

Home. I spend a lot of time at home, and I have several.

I like to make homes, to unpack, and decide where everything lives. I have traveled thousands of miles to be with a friend as she made a home, and a man I love builds them.

Rooftop plants, thirty-three of them, of all sizes, some flowering, some fruit-bearing, a few are gifts, one I found on a street, and maybe the most loved is a lotus in a clear glass vase. Like furniture, they have been in different places over time. And the vase broke.

I just watered the plants, something I do at night, when I am quiet. I think I might hear the water seep. The bak lan, osmanthus, jasmine and orange are all flowering, and the night the cereus bloomed, the huge white fingery flower that opens one night a year, a rat also came out. At the lunar year, even more flowers, cut or bulbs. Forsythia or strings of gold. Pussywillow or narcissus. Maybe a magenta hyacinth.

Writing is a way of reliving. When I was on the roof, I knew I would come downstairs and say this to you.

2011

I was away from this city for a year, and returning, I see people as more tired. Less healthy. I feel life is harder. A different tone. An uneasiness, an uncertainty, I don't want to call it desperation.

Food costs so much more. Prices are up around the world, and when I go to the wet market here for the first time, looking forward to the vegetables and fruit in their color, I am surprised at the prices. When I go to the cooked food market for lunch, the food is as wonderful as ever for the kindness of the people who work there, but even here the cost is up. Rents are up too.

I have known that one out of six people in this city is poor. Now I can feel it. I have known that our income gap has been widening. I feel that too. Hunger is even happening.

Maybe we have always known this. Maybe capitalism makes sure we know it. Work, work harder, longer. Deal, deal tougher. Get the lowest price for what you buy, no matter what, and get the highest price for what you sell. Then you will get there.

Then you will get there. Tired. Unhealthy.

VIGIL

Every year in the city's largest park, we remember.

We tend tens of thousands of candles like cells of a very living thing, in unqualified freedom.

Every year, the cicadas whir in desire.

Flame trees flame.

One man holds a lotus lamp, plastic, white. It fits in the palm of his hand.

SLOW

A poet who lives in faraway mountains comes for a visit.

He says the city is growing too fast, that it is too big, but so is everywhere else. He last visited sixteen years ago.

When a poet from the city counters that about three-fourths of our land is not developed, the visitor answers that it will be. He says that in his country, the national parks are not protected forever, that the government can take them anytime.

Another writer visits. He trusts the world. He once traveled eight thousand miles with no money, relying on kindness instead. He says that around every city, there should be a radius of farmland and that his family has been vegetarians for one thousand five hundred years.

I think of a community who lost their land. They could have accepted a free home in exchange, in another location, but they chose a place nearby, close to land, and each other.

And I think of others who may lose their land, their islands. There are proposals to make new land masses, to fill in the sea, connect one island to another.

Some call it land reclamation. I call it moving the sea.

And I say a slow seeing is the revolution of kindness.

TWO HUNDRED PEOPLE

A creative writing workshop. Two hundred people sit in one room, trying to touch words, and I ask us to be careful.

And when a poet asks to make a book together, I say yes.

SKYSCRAPER, MOON, SEA

There's a skyscraper being made in the neighborhood, maybe seven times higher than the buildings around us, and the rent will probably be that many times higher, too.

It is still wrapped in scaffolding nets, so we see an absurd amount of artificial green by day, and in the evenings, when a strong light is thrown from the very top, there is always shadow, whatever the phase of the moon.

I once walked home across a moonlit mountain. The mountain was the center of an island – one boat traveled to one side, another boat to the other – and I would cross the divide when the moon was in its fullness. I passed caves, one-room schools, scarecrows, silver chickens, two beaches, and when I opened the front door to my home, I sometimes waited to turn on the light, wanting to stay in the mid-darkness a little longer.

A writer from a very quiet island once came to the city. One night, as we waited at a crosswalk, we looked up at a mass of green scaffolding and called the netted wall a vertical tropical sea. Another one of our pretty lies.

M

Here, women call their monthly cycle M.

Children may learn about M when a certain company comes to their school. Girls will be customers and get a sample napkin. And the boys get curious.

A man I know prepared his daughter for her M. A zipped and equipped pouch stayed in her schoolbag maybe one year ahead of time.

Acupuncture took my pre-M pain away. I had often needed to be flat on my back on the first day, but after one session of seven needles in my abdomen, the back pain left, never to return. Sometimes the moods stay.

The supplies we need for M are usually tucked in the corners of shops, but on the bus, where commercials play in a loop for all to see, there are advertisements for products that take the smell of M and other things away.

-LESS, -NESS

I have one room of whiteness. I need this.

White bed, chest, walls, door, pillows and cases and covers, four thin curtains that move with air from open windows, and many books inside a lidded white box.

In this space, I am less. Lighter. Brighter. I feel placeless, timeless, and a deep peace.

I once knew a family whose home was also white. White furniture, white appliances, white fabrics, white walls and ceilings, bleached white floorboards, white garments. I remember everything in their home being white.

I remember I did not feel peace there as much as an effort at peace. I wonder if people coming into my room feel the same way.

INSECTS

On the first night at my home on a carless island, we slept on a mat on the floor.

I felt something at my left hand, and somehow knew, in the sleepy darkness, that it was a centipede, red and orange and scaly. I leapt, flinging the hundred legs across the room, where they scurried along the base of the wall, never to be seen again. Nor the mate.

Another night, I woke to my face covered in ants. The whole home filled with the weak-winged things. The red and green beams were being eaten.

Later, the bed perfect, mosquitoless, in its white net canopy. And a few minutes after we turn out the lights, the geckos come out to laugh.

TOILETS

I have lived in two neighborhoods sufficient with public toilets. Clean. Bright. Open until midnight. And always supplied with paper.

I have never seen a cockroach, rat, or any person there who has made me feel afraid.

LUNCH BOX

On the fifth floor of a grey concrete building, two families lived side by side.

Our back doors opened to an alleyway three blocks from the sea, which we could not hear or smell.

There was no gate at the street level, so anyone could enter. A taxi driver once escorted my sister all the way up the late night steps. A few times, people knocked at our doors to talk about their beliefs, and social workers brought us disinfectant during SARS.

One month, we shared electricity, a white cord running through the bars of our gates. The next month my neighbors moved out.

They left without a word. But in a pile of belongings on the floor, they left a lunch box, circular, aluminum, and lidded.

Then one day I met a friend in an elevator.

We both work on the ninth floor of the same office building. It was lunchtime, and she was carrying a stainless-steel lunch box filled with rice and veggies she had purchased

at an eatery down the street. She also had a thermos full of their soup. My lunch was inside paper and plastic.

She turned left as we arrived at our floor. I turned right.

To reach my desk, I had to pass a group of schoolchildren, and walking past them, I knew I had made a mistake with my processed sandwich in throw-away packaging.

These days, I like using my neighbor's lunch box, Rings Brand, made in Hong Kong when it was still a manufacturing center.

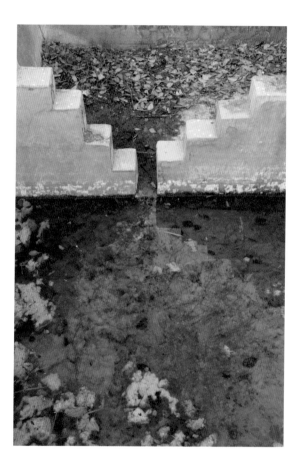

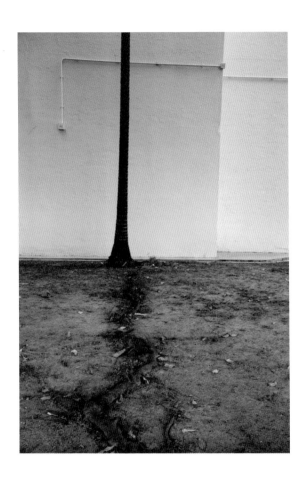

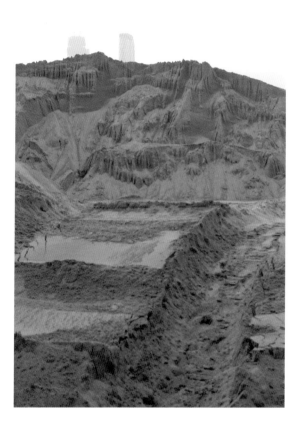

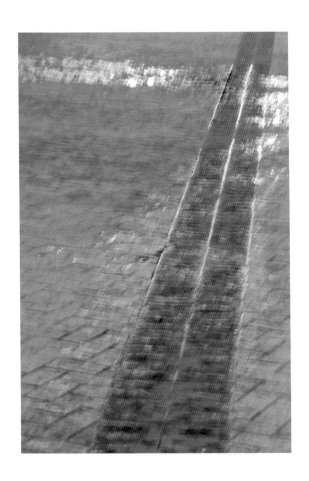

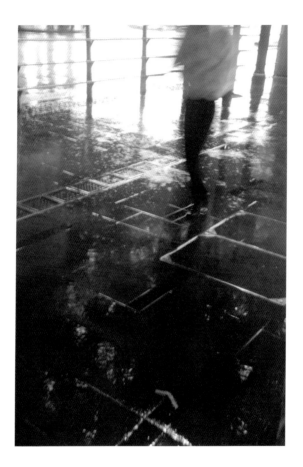

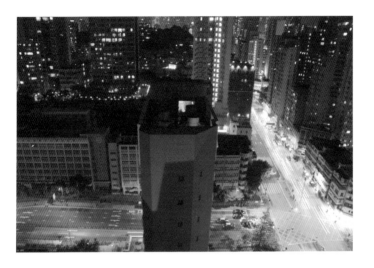

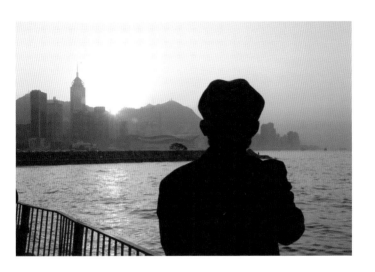

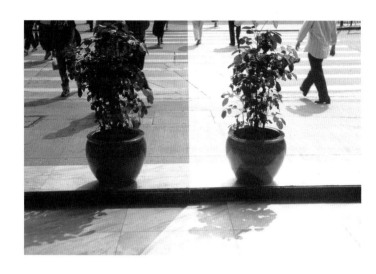

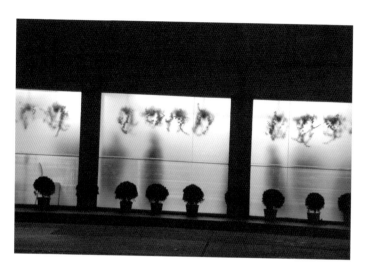

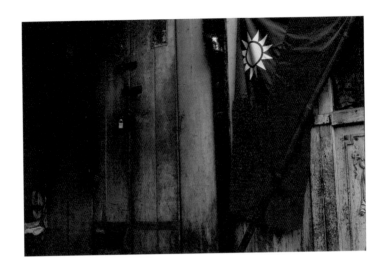

KNEES

I know of elderly people who can only afford to live on high floors of buildings without elevators, and when they climb up, their knees hurt for so long that they do not leave their home for months.

HAVE YOU EATEN?

When I moved into my neighborhood, there were two twenty-four stores. Now there are three.

Over-processed, over-priced, over-packaged, over-lit, and the workers probably underpaid.

Yet there is always a free microwave, hot water dispenser, condiments, and air-conditioning or heating, depending on the season. Whole meals in their packages might be found nearby, thrown away upon expiry, maybe with a one-dollar coupon inside.

I know of a family who eat out once a week, sharing one discounted set meal. The child hates to leave, sees the fast-food eatery as spacious compared to their twenty-four square foot home.

I once went to a man's tiny home. A tall man with kind eyes. He tends his room and himself with care. I remember a cot-sized bed, rice cooker on a ledge, hot water kettle, and a bag of oranges. He pays more per square foot than I do and shares the toilet with eight people who live on either side of a hallway.

There are three convenience stores in my neighborhood and one food bank. I know of a man who brings used bags from the supermarket to collect his items. He works at a hospital but does not earn enough to buy food and does not want his neighbors to know where he gets his supply, probably dried and canned.

Some people say they are 'going to a party' when they eat free meals from the community. When I went to a 'party' one Tuesday night, most people who received the food and the proselytizing were elderly people, many in wheelchairs. Some of the volunteers who served the rice boxes had large tattoos. Everyone got a banana.

DRIVER

I am late and take a taxi. She thanks me for the order.

She is late too. Her car had needed servicing, so she is two hours behind schedule. The twelve-hour day usually starts at eight o'clock in the morning.

This job is too hard for women, she says, too physical. When I ask her how long she has been driving, she says not to ask, that she is old, only works weekends now, part-time, just a little money.

It is Saturday and we are driving east. Suddenly she slows slightly, looks into another taxi, in the middle lane. Her boss is driving, the man who rents her this vehicle. She does not answer when I ask her if many drivers rent.

She wants to talk about food. 'This weekend, there is red wine for ten dollars. Today. Tomorrow. And a free shuttle bus. A free bus! One bowl of noodles, enough to fill you. Go, lah. And sweet biscuits from Italy, I want to go, I love them, but I look at the box, cannot read anything, how can I find the second box to buy? I want to go and eat them again, but I have to work. You go, lah.'

She leaves me at my destination one minute ahead of time.

CLOSE, CLOSER

When I first came to this city, I saw no kisses in public, and few people held hands.

Classmates would walk arm in arm, boy with boy, girl with girl, but later, when they began the workaday phase, the closeness left.

We followed this habit some of the time but would also love each other's hips and lips and skin.

Our skin was not the same color. There were stares. And once, when we traveled to the motherland, a hotel clerk asked us to prove that we loved each other.

Now, years later, there are many visible pairs of bodies. Kissing, leaning, holding. Close, closer.

It is the older couple I especially like to see. Somehow softer, warmer. And final.

WEDDINGS

Before I could live with this man, his deceased brothers had to be settled. Were there two or three who died of illness, I am not sure. His parents did not speak of those sons, just as my parents rarely speak of my brother, also taken too young.

His mother arranged weddings for her boys, each bride a child who had also died. My parents gave their son to a grave and to God.

And then we had our wedding, a red event on a little island with an inn. We believed in our story, and there was love.

I became an Auntie. Every Sunday, the family ate a large meal together, many round dishes in the middle of the table that doubled for mahjong and where I trained in chopsticks. Almost every family photograph is around this table, and the television is probably on.

Twelve years later, we parted. Sometimes I see him, sometimes the nieces, and for a while, his sister lived on the street where I work. The family does not speak about the end of our togetherness, but I have heard some of the stories.

Now, when I am invited to a wedding, I usually go to the joining over word, not over food, which I have come to see as private.

And yesterday, I chose a bright red umbrella, with a frilly fringe. Maybe for rain, maybe for sun, or another red event.

MORE THAN A CAT

A cat once walked into our home in the city. The back door had been left open for some wind to come through, and the cat came in with it, maybe taking five flights of stairs.

A friend from another country said this would bring good things, and a few weeks later, the cat gave birth to six kittens in the middle of the living room floor.

We watched as each one slipped out of her body, and as she ate the placenta. We did not speak.

She licked them all, but one did not live.

The cat's next home was with trees and snakes and butterflies and many living things. She and one of her kittens came in and out through an open window. One night, when much of the neighborhood was asleep, there was an attack by a pack of dogs. She was never seen again.

A friend once made a film about love and need. If we lose what we love, she said to please love even more. One man, dogless, began again with a black-nosed cat. Another friend, catless, gave birth to her first child and took in another cat.

And when I was alone, broken, I began sending out an image and a handful of words every day. Around the same time, I started the habit of touching people on their shoulders while speaking, or maybe touching in place of words.

TRUST

I met a man at about three o'clock in the morning.

He sang a song, I read a poem, and there was trust.

I did not know how famous he was until the day I opened a drawer in his home and saw maybe twenty pairs of sunglasses.

A VERY LIVING ROOM

One of my living rooms is near a patch of trees, two rabbits, and how many cats fed by volunteers. It is a bar, the only one I go to.

I like the house guitar and *gujin*, the eyes of friends, shelves of books, jugs of water, and the garden to take fresh air. I like to lean against the stone wall as if I am touching Earth, and to dial the black telephone near the entrance.

I like the sculpture of paper, the mural of maybe forty colors, an inky skyline print, a two-word poem, and three shiny pieces of pottery that tell us there is hope.

We come, we kiss, give, receive, believe. We believe in every living thing. More than once, we talked overnight, and more than once, I needed you. And you.

And when we need to excuse ourselves, we step into a smaller room where every sound in the bar carries. There is effect.

For years, my home was minutes away, and I would come, be with friends, be with self. I learned to sing poems in this room, and how many, always with guitar.

One friend sounds like a nighttime river, still, yet moving. Another sings awe. One voice used to bring longing, the voice of an erhu always does, and the mandolin flirts a little.

A few nights ago, I spilled a glass of wine. Full, red. It fell on the lap of probably the wealthiest person in the room. Mink coat. Fine black evening wear. White handbag. When I told the story to a friend, he asked if it was really a mistake. I said yes.

SIX MONTHS

We once lived in a home that would be torn down six months later.

It was two homes. I worked in one, he in the other, and we shared one courtyard, bed, and a single roof, of clay, upon which the falling of rain was like fingertips.

In six months, the man who owned our homes would have enough money to tear them down and make six homes, blue-roofed, and without a courtyard facing west.

A friend asked me to save some of the green and white floor tiles, but I didn't and I am sorry.

OF SOUND

Four of us once followed a flute and a man through a valley.

A woman I know likes to be in a room full of leaves.

Of all the footsteps in the hallway, one person always chooses shoes that create crispness, just as I prefer coins down the metal chute of a tram.

Happiness does not reside alone. It can be Cantonese, outward, playful, communal, like a round table on a cool evening, or maybe the hum and horn of an overland train.

Every morning, I sing on the way to work, and the other day, we all sang on the MTR, but we are not supposed to talk in the elevator. A laminated sign says that disease might happen.

A dog who howls from a forest, from a deep need, lives on the rooftop next door. I wish him his wishes.

LUNAR

There was a time when I would look up from any street and see the moon.

Moon. The name I gave to a writer. Lunula, for another. And one was born with the moon and three suns in his name.

More than one hundred times, we have come together for the moon, new or full. Sometimes we go to a village that is four hundred years old and see the moonrise, faint as hair, then fattening, land darkening, and some stars.

And in the home, I keep a box of Moonstrips.

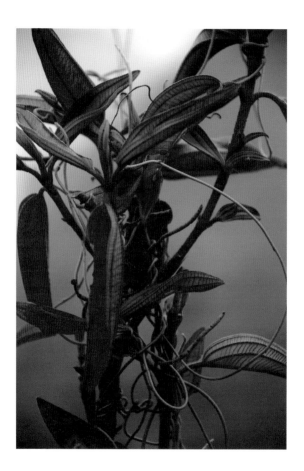

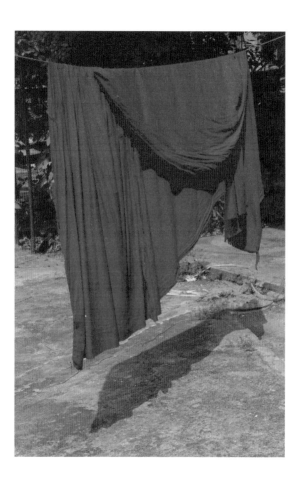

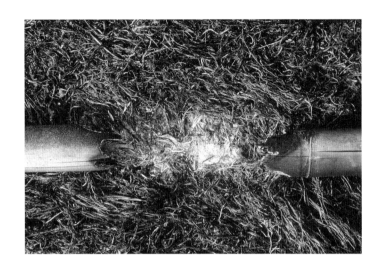

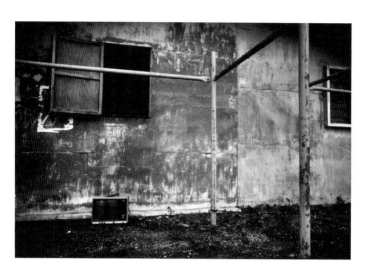

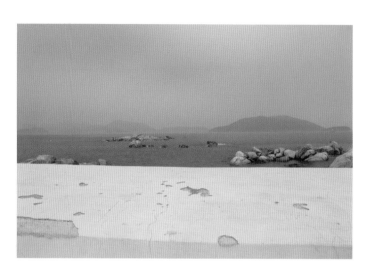

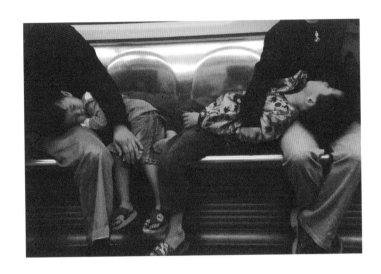

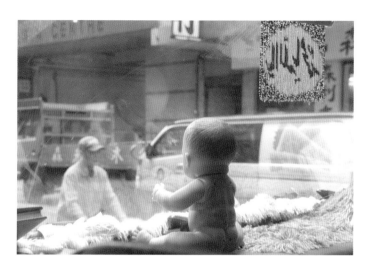

STORIES

IMAGES

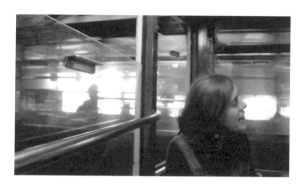

Madeleine Marie Slavick 思樂維

A writer and photographer, Slavick has exhibited her photography internationally and has edited about thirty books. She has also been a writer with Oxfam, a social worker with elderly people, a counselor with teenagers, a teacher of English and Writing, a campaigner for environmental issues, and a photographer with assignments in Brazil, China, Indonesia, India, Korea, The Philippines, South Africa and Vietnam.

Slavick has lived in Hong Kong longer than anywhere else. She writes and photographs every day on her blog: touching what I love.

FIFTY STORIES FIFTY IMAGES
Madeleine Marie Slavick 思樂維

Published by MCCM Creations 2012
http://mccmcreations.com
http://mccm.wordpress.com
info@mccmcreations.com

Acknowledgements to Oxfam and to the editors of *South China Morning Post* and *Bluesky Kids*, where 'Have You Eaten?' and 'Lunch Box' first appeared in earlier versions.

ISBN 978-988-15217-5-0